OXFORD
PRIMARY
art

Modern art

Norman Binch

Oxford University Press 1994

Distortion

Artists do not always try to make things look 'real'. Modern Artists often *distort* things or paint impressions of them.

This is a painting of a woman sitting down.

 Can you see the figure?

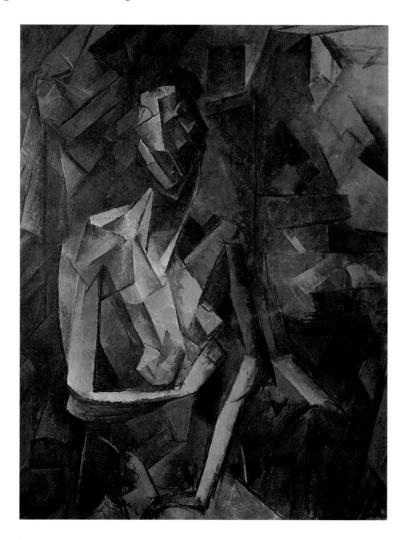

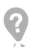 Can you see something odd
about this self-portrait?

 What do you think this
painting might be about?

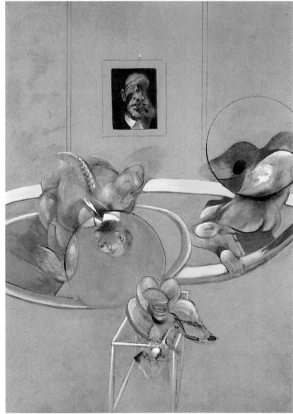

3

Ideas for modern sculptures

This is a drawing for the *carving* in
the next picture. It was done to help
the artist to imagine what it would be
like.

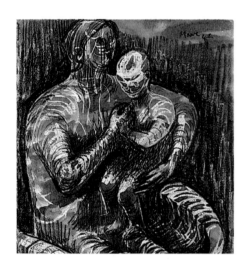

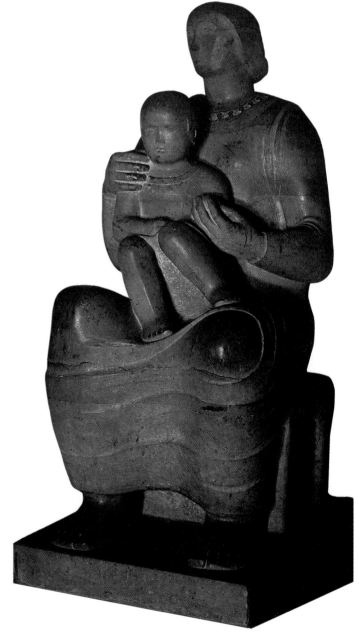

This is a round *pot*. You can only see the man's head when you look at the edges.

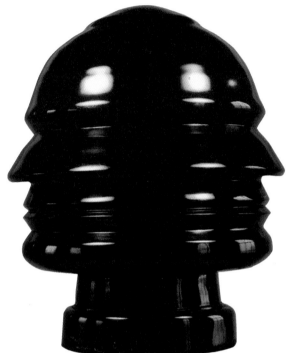

This looks like a creature from another planet.

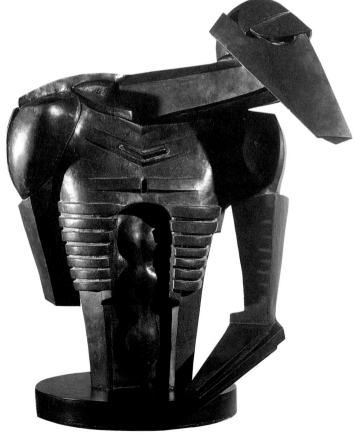

Ideas from animals

This painting of an elephant might be from a dream.

 What is strange about it?

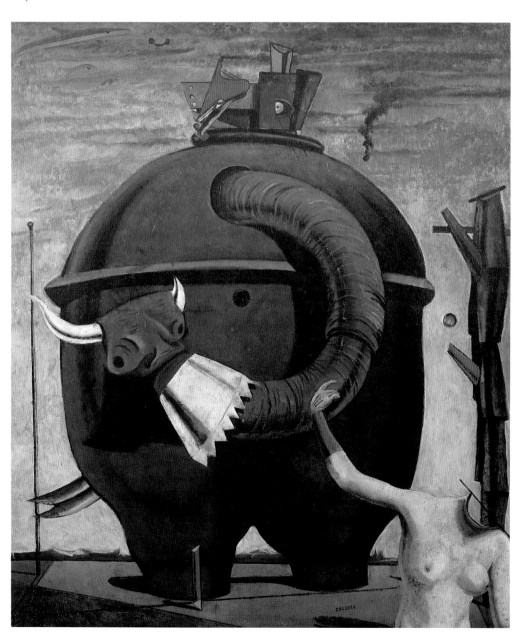

These sculptures are not quite 'lifelike' are they?

Do you like them?

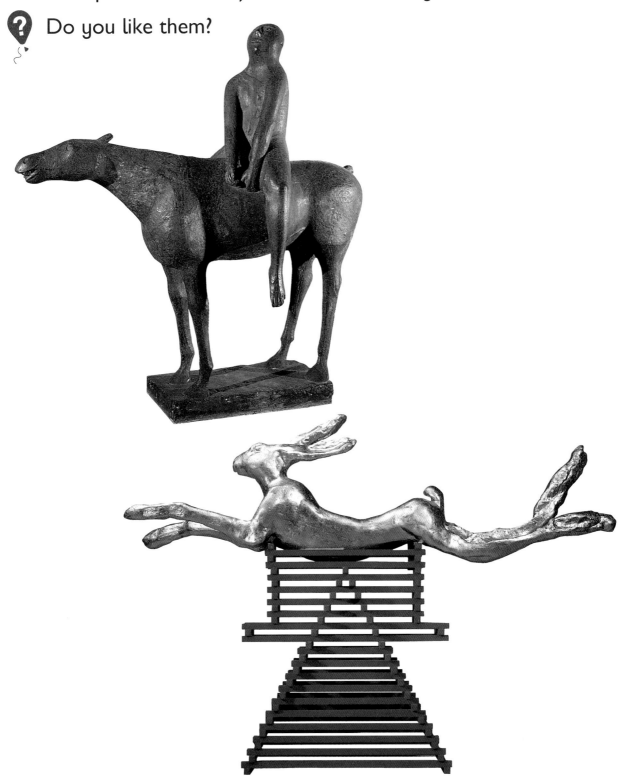

Decorative ideas

Some very old art is not 'realistic'.

Artists used their imagination to make ordinary things more interesting. This is a Mexican pot which is *based on* a woman lying down.

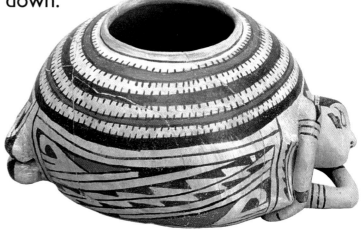

This is a brooch based on a dragon with two heads. The people who made it were called Aztecs. They lived in Mexico.

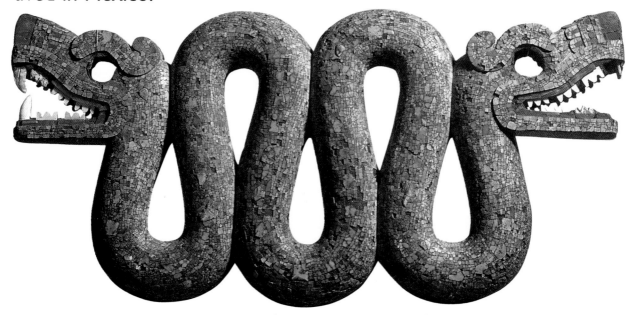

Movement

In these two paintings the artists are trying to show us how things move.

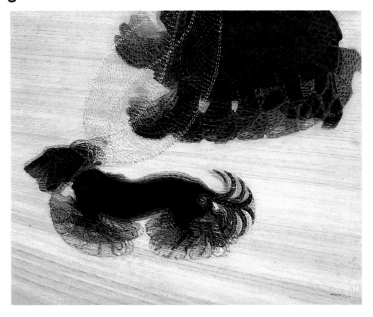

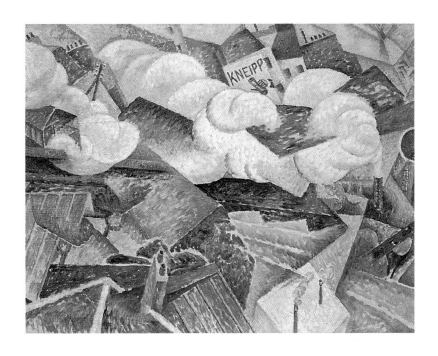

Feelings

This is a painting called 'Questioning children'.

 Does it look as if these children are asking questions?

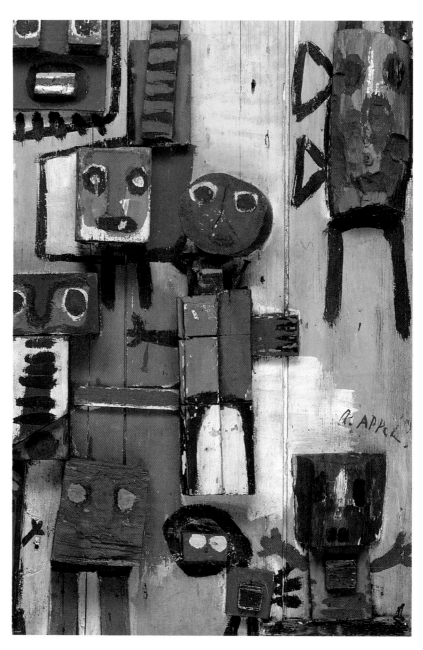

Ideas from simple objects

These paintings are of ordinary things like pottery and bananas.

You can see into the pots at the bottom of the painting but not into the ones at the top.

 Why do you think this happens?

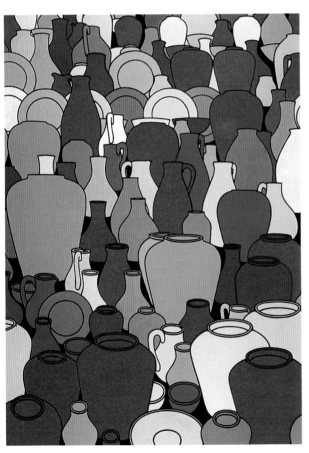

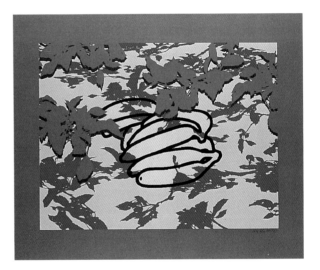

Patterns

This was made by *printing* lots of pictures of a film star's portrait to make a pattern.

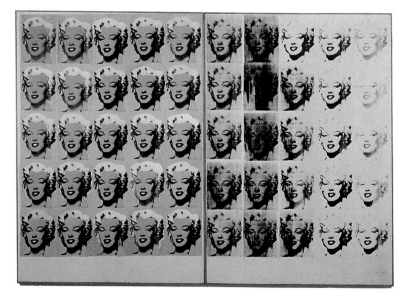

This is a poster advertising Persil washing powder.

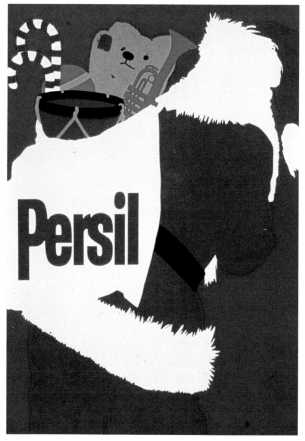

Ideas from scrap

This is made from scrap metal - like empty drink cans. It shows two sea birds sitting on a buoy.

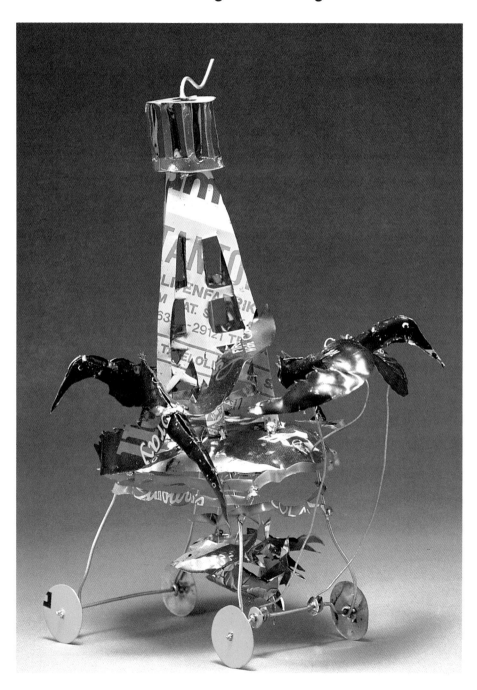

Homes and houses

This is a picture about things used in science.

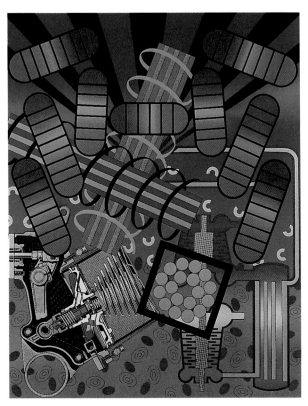

This sculpture is called 'The Home'.

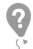 Can you think why?

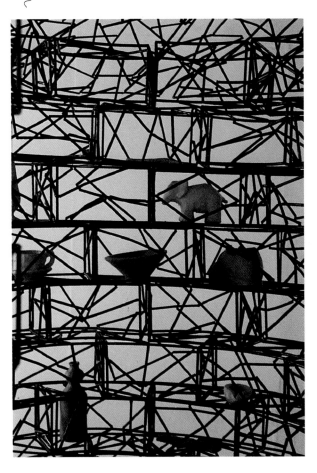

This is called 'The Tree House'. It is all made from paper.

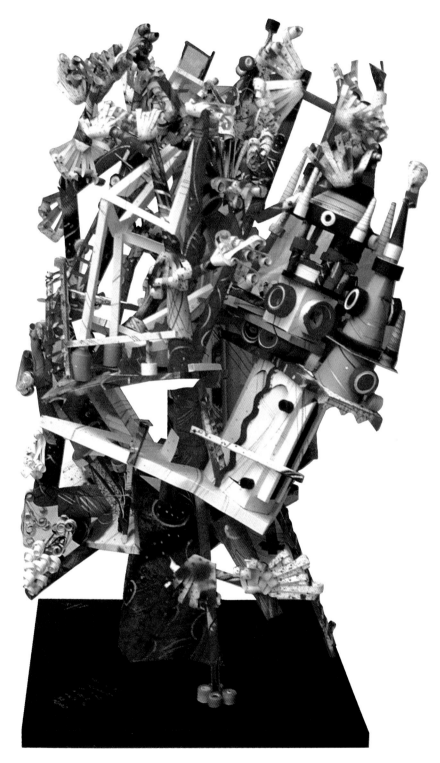

Ideas from the countryside

If you look carefully you can see that these paintings are of the countryside.

This is a painting of hills in sunlight.

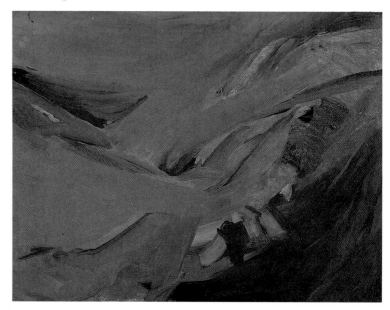

This painting is called 'Rain'.

Can you see the rain?

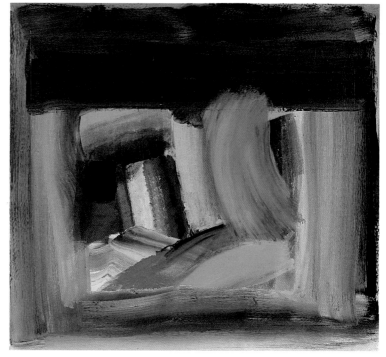

This is called 'Entrance to a Lane'.

 Can you see it?

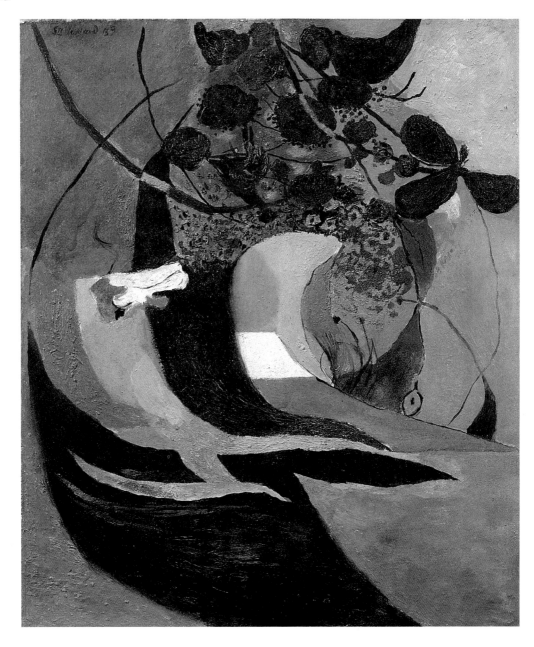

Imagination

Can you say what this painting is about?

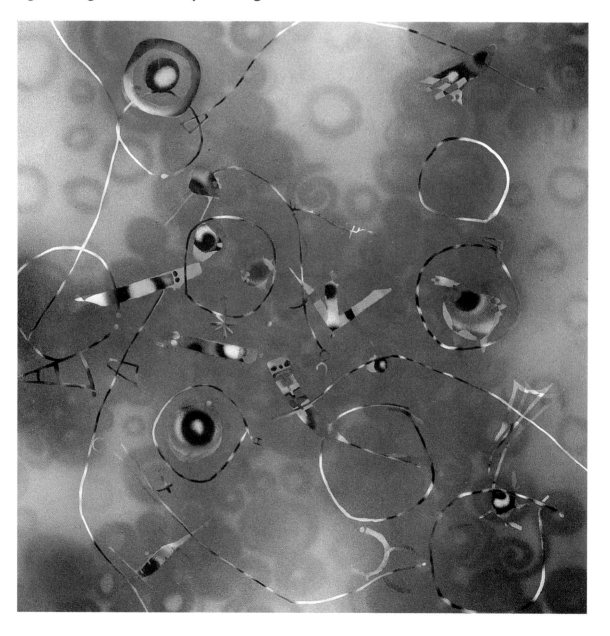

These two paintings are by the same artist. They almost look like photographs don't they?

 Can you think how he might have made them?

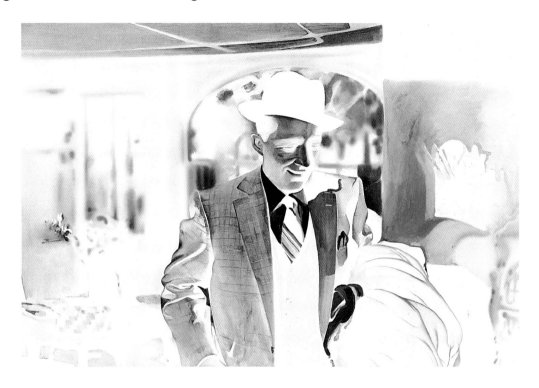

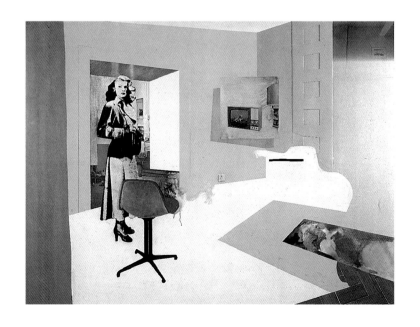

Using stripes

This is called 'Benches'. There are eight pictures of
benches in a park taken at different times.

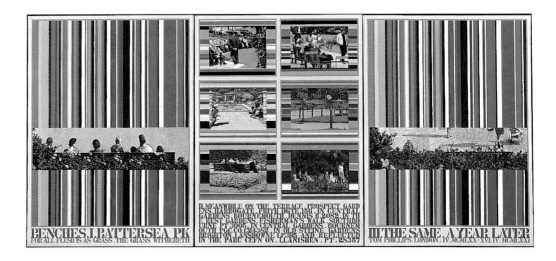

This is made up of
coloured stripes. It is a
spiral inside a square.

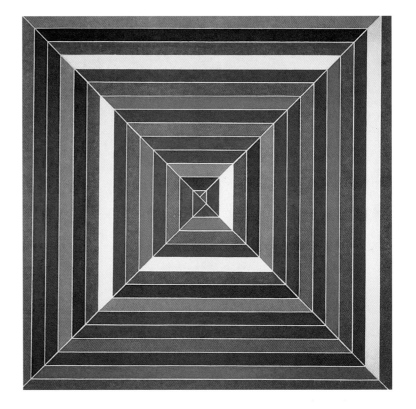

An idea for a monument

This collage is called 'Lipsticks in Piccadilly Square, London'.

 Can you imagine them in your school playground?

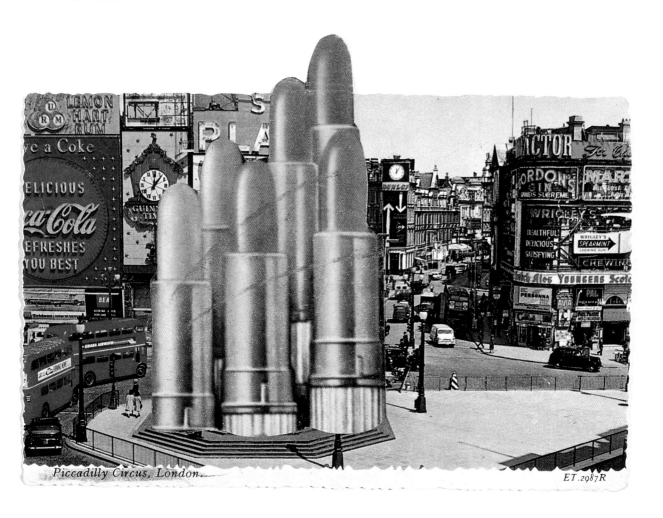

Piccadilly Circus, London.

Things to do

Make a drawing of a model you want to make.

Try to make it from the drawing.

Make some models of animals and birds out of clay, plasticine or scrap materials.

Build an imaginary house from cardboard boxes and paper.

Try to make a drawing or a painting to show how something moves.

Make a pattern out of fruit or pottery.

Make a pattern out of squares or stripes.

Cut up some coloured paper into squares and use them to make up a picture of an animal.

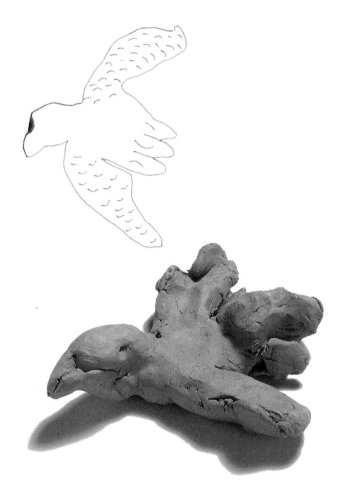

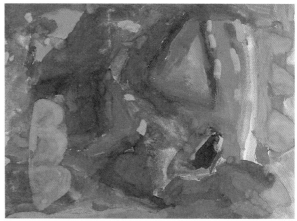

Make a painting of the colour red. Try the same thing using yellow or blue.

Make some paintings of your idea of rain, sunshine or wind.

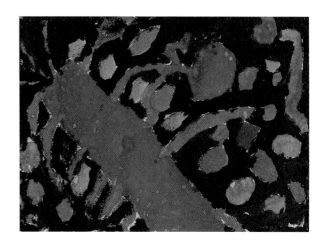

Take some photographs of one place at different times of day and put them together. Look at the differences.

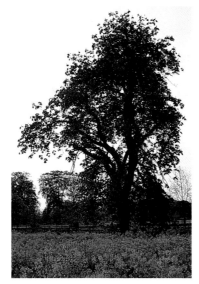

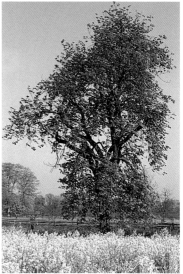

Words to remember

Distort	When you put something out of shape
Impressions	When you paint or draw things very quickly
Abstract	Paintings and sculptures which are not of real things
Printing	A way of making a lot of pictures exactly the same. If you put paint on your fingers and press them onto some paper you will have your finger prints. You can repeat this many times to make a pattern if you like
Self-portrait	A picture that you draw or paint of yourself
Carving	When you cut away material (like stone) to end up with the shape you want
Pot or pottery	Things like cups, bowls or vases made from clay. They are then heated (fired) to make them very hard
Collage	Pieces of paper or other material stuck on to paper to make a picture or a pattern

Oxford University Press, Walton Street, Oxford OX2 6DP
© Oxford University Press
All rights reserved
First published 1994
ISBN 0 19 834817 7

An acknowledgements list for the pictures in this book appears in the *Teacher's Resource Book*.

Printed in Hong Kong